I draw, I paint

watercolor

Text: Isidro Sánchez
Paintings: Miguel Ferrón and Jordi Segú
Illustrations: Francesc Martínez

All inquiries should be addressed to:
Barron's Educational Series, Inc.
250 Wireless Boulevard
Hauppauge, New York 11788

Library of Congress Catalog Card No. 91-15062

International Standard Book No. 0-8120-4717-6

Library of Congress Cataloging-in-Publication Data

Sánchez, Isidro.
 [Yo dibujo, yo pinto acuarela. English]
 Water color : the materials, techniques, and exercises to teach
yourself to paint with water colors / by Isidro Sánchez ; paintings
by Miguel Ferrón and Jordi Segú ; illustrated by Francesc Martínez.
 p. cm. — (I draw, I paint)
 Translation of: Yo dibujo, yo pinto acuarela.
 ISBN 0-8120-4717-6
 1. Watercolor painting—Technique. 2. Artists' materials.
 I. Title. II. Title: Watercolor. III. Series.
 ND2420.S2613 1991
 751.42'2—dc20
 91-15062
 CIP

L.D.: B-7154-91
Printed in Spain
1234 987654321

I draw, I paint

watercolor

The materials, techniques, and exercises to teach yourself to paint with watercolors

BARRON'S

What is...

Learning Watercolor Painting

This book is both for reading and *using*. Read it very carefully, trying to understand all of the techniques that are explained. Then, *using* it, practice everything that you have learned.

Like the other titles in the *I Draw/I Paint* series, this book has been designed as a tool to teach you drawing and painting. It will teach you *what watercolor is*, *what materials to use*, and *how to paint watercolors*.

As you begin painting your own pictures, you will be more and more attracted to watercolor, a painting technique characterized by its clean, pure, transparent colors.

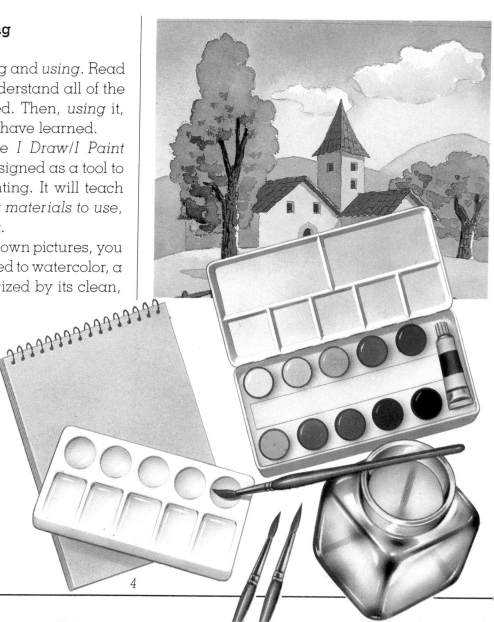

The landscape you see on this page could be one of your first watercolors.

Watercolors are transparent

Watercolor is a painting technique in which colors are diluted with water. Wet the color with a damp brush. The color will be lighter or darker depending on the amount of water you apply with the brush.

The most distinctive characteristic of watercolor painting is its transparency. When the colors are diluted with water, the white of the paper below can be seen.

When you paint in watercolor, you must keep two important factors in mind:
- *Paint light colors first and then darker colors.*
- Take advantage of the paper itself to provide the white. (White paint is available, but it is used only in special cases.)

WATERCOLORS ARE TRANSPARENT:

For example, if you paint a yellow strip, and then, when it is dry, cover it with a blue strip, both colors blend and produce green.

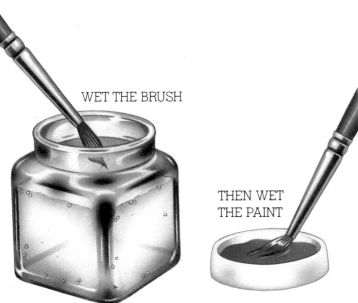

WET THE BRUSH

THEN WET THE PAINT

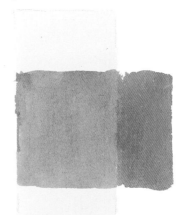

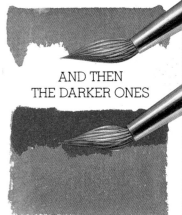

PAINT LIGHT COLORS FIRST

AND THEN THE DARKER ONES

What I paint with...

What are watercolor paints?

There are two types of watercolors: cakes of dry watercolors and tubes of thick, moist watercolors.

To pick up color from a dry watercolor cake, it must be rubbed constantly with a wet brush. Dry watercolors are best for beginners.

Watercolor tubes are suitable for more advanced students.

Now you can do your first exercise in watercolor painting using a box of dry watercolors.

Use the box cover as a palette to blend your colors.

THE COLORS YOU NEED:

1. Light yellow	5. Red	8. Light blue
2. Dark yellow	6. Light green	9. Dark blue
3. Yellow ocher	7. Dark green	10. Black
4. Orange		

THE BOX COVER CAN BE USED AS A PALETTE TO BLEND THE COLORS

ROUND CAKES OF DRY WATERCOLORS ————

SQUARE CAKES OF DRY WATERCOLORS ————

TUBES OF THICK, MOIST WATERCOLORS

YOU MAY SUBSTITUTE DIFFERENT COLORS ACCORDING TO YOUR NEEDS.

TUBE OF OPAQUE WHITE

WATERCOLOR BOX

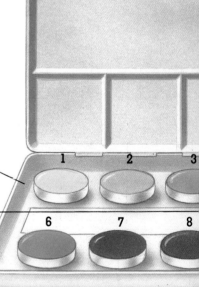

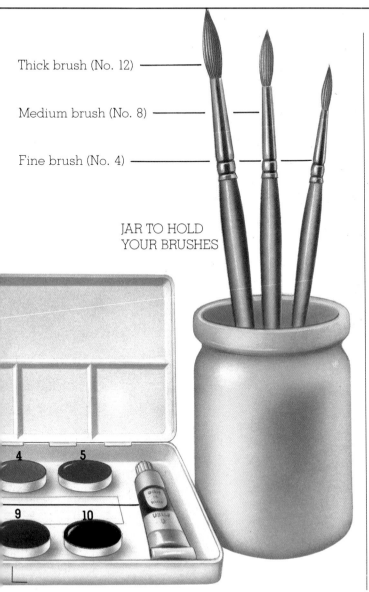

Thick brush (No. 12)

Medium brush (No. 8)

Fine brush (No. 4)

JAR TO HOLD
YOUR BRUSHES

4 5

9 10

What are the brushes like?

If you have never painted before, the brushes may seem a bit unwieldy. However, they will soon become easier to manage.

There are several sizes of brushes, depending on the amount of hair they contain.

Sizes are identified by a number on the handle, from 00—the finest brush, to 14—the thickest one.

The variety of qualities and thicknesses shouldn't bother you. You just need two or three round brushes—numbers 4, 8, and 12.

How to take care of your brushes

- Avoid letting paint dry on the brushes.
- After painting, wash and dry the brushes, smooth them out to their original shapes, and store them *with the hair pointing up*.

What I paint on...

Watercolor paper

For watercolor painting you should use special *watercolor paper*.

You can find *smooth (hot-press)*, *medium (cold-press)*, and *rough* paper. Smooth paper is for detailed work. Rough paper is for freer painting but is difficult to use. Medium paper is best for beginners.

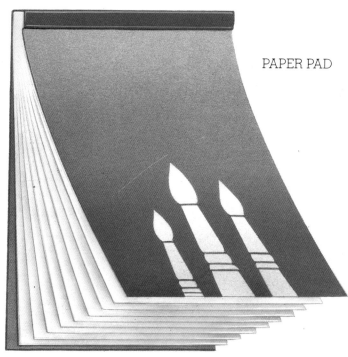

PAPER PAD

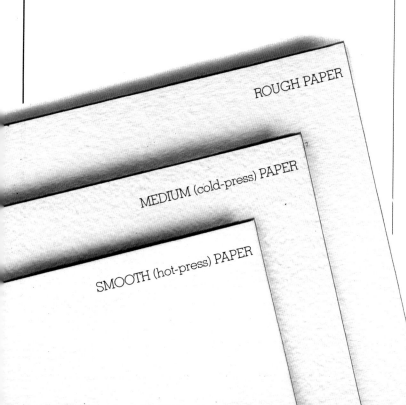

ROUGH PAPER

MEDIUM (cold-press) PAPER

SMOOTH (hot-press) PAPER

Watercolor paper in pads

Watercolor paper comes in loose sheets and in pads mounted on cardboard.

For your first watercolor exercises, the best thing to use is a watercolor pad.

How to stretch watercolor paper

Many experienced painters use sheets of watercolor paper that they *stretch themselves*.

Stretching paper prevents it from warping and forming pockets when the watercolor dries.

Moisten the sheet of paper under a water faucet or with a sponge. Place the wet paper on a wooden board and smooth it out with your hands.

Working quickly, fasten the paper to the board with a strip of gummed tape along one of its edges. While still smoothing it, tape the other edges.

After drying in a horizontal position for three or four hours, the paper is ready for watercolor painting.

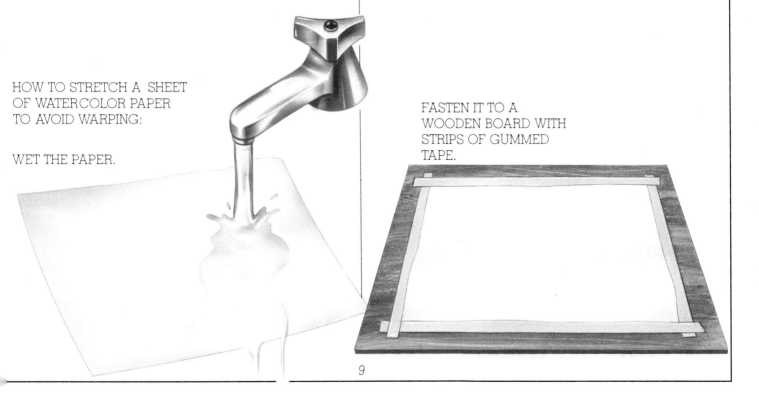

HOW TO STRETCH A SHEET OF WATERCOLOR PAPER TO AVOID WARPING:

WET THE PAPER.

FASTEN IT TO A WOODEN BOARD WITH STRIPS OF GUMMED TAPE.

What I paint on...

A drawing table and a drawing board

Have you decided where you will do your painting?

If you have your own room, you already have your artist's studio.

The table or desk on which you do your homework is fine for watercolor painting. Just cover it with paper to avoid getting it dirty.

You can also place the pad of paper on a wooden board. Then, hold one end of the board on your knees and prop the other end against the edge of the table while you paint.

These are the *materials* a watercolor painter needs: a watercolor box, a pad of paper, brushes, and water containers. Also, a roll of paper towels for squeezing out the brush and a sponge for absorbing water or color.

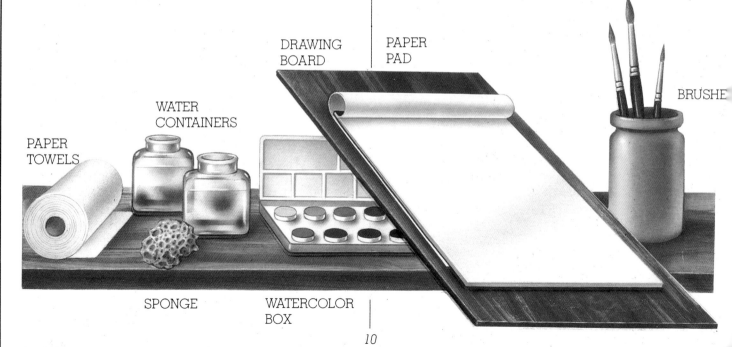

DRAWING BOARD

PAPER PAD

BRUSHE

WATER CONTAINERS

PAPER TOWELS

SPONGE

WATERCOLOR BOX

WATER
CONTAINERS

Water containers

In watercolor painting, water to dilute the colors is as important as the colors and brushes.

You will need two glass jars with wide necks. Fill both with tap water.

One jar is reserved for rinsing and cleaning the brush each time you change color. The other jar is used to wet the clean brush before picking up a new color.

Paper towel and a sponge

You need very few additional materials—just paper towels, like the roll used in the kitchen, and a sponge.

PAPER TOWEL

SPONGE

Since the use of watercolor involves wetting the cake of color with a brush, the paper towel is very useful for squeezing out the brush or drying the brush after washing it when you want to change color. The sponge absorbs some of the freshly applied watercolor, if desired.

How I paint...

How to paint

You've collected your equipment and you're ready to start painting. Before actually beginning to paint, however, you should do several exercises on a piece of test paper.

Choose a color and dilute it with more or less water. Notice how the color intensity varies depending on the amount of water used.

WITH A LITTLE WATER

WITH MORE WATER

The basic watercolor technique: Wet the brush and rub the color. Depending on the amount of water used you will get lighter or darker tones. For instance, if you pick up a color with an almost dry brush, you will have a dark tone; if you use a little more water, the color will be lighter; and if you use a great deal of water, you will have a pale color.

WITH A LOT OF WATER

The direction of the brushstroke

You should be able to handle the brush well before starting to paint. Practice your brushwork over and over again on a piece of test paper before beginning.

Pick up the color with the brush, squeeze it out on the paper towel, and place the tip of the brush on the paper. Press the brush until the tip bends a little and paint a horizontal strip.

The importance of this exercise lies in the boldness of your brushstroke, which should be a continuous one. If you cannot do it this way in the beginning, don't be discouraged. Try it again and again.

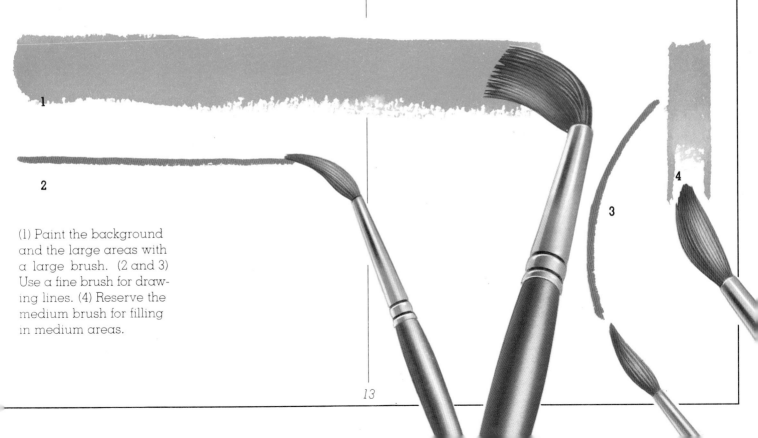

(1) Paint the background and the large areas with a large brush. (2 and 3) Use a fine brush for drawing lines. (4) Reserve the medium brush for filling in medium areas.

How I paint...

How to paint an even background

To paint an even background in watercolor—that is, in a uniform color—is not difficult, but you must practice doing it.

Wet the brush and pick up a little blue color from the cake. Paint a horizontal strip, pressing the brush against the paper to make a wide strip.

If the board slopes at an angle, the color will accumulate on the lower edge of the strip. Paint another strip below the previous one, and so on until the end.

When you reach the lower edge, there will be an excess of color. Wash the brush with water, dry it with a paper towel, and apply the tip of the brush to the color that has accumulated on the lower edge. The brush will act like a sponge and soak up the excess wash. And you will have an even background!

PAINT A HORIZONTAL STRIP

SOAK UP THE EXCESS COLOR

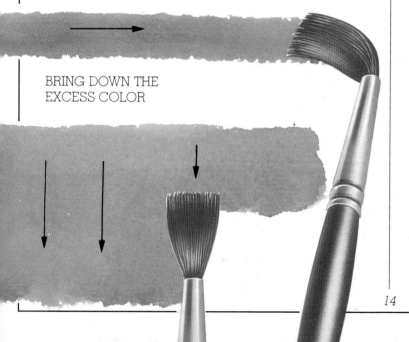

BRING DOWN THE EXCESS COLOR

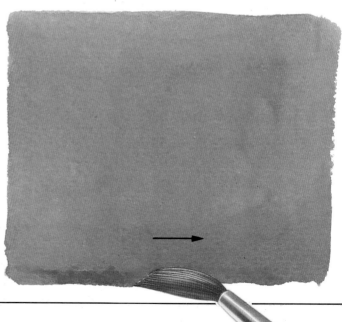

14

Learning to gradate colors will be very useful for shading. Study the text carefully and do the exercise on this page on a piece of test paper.

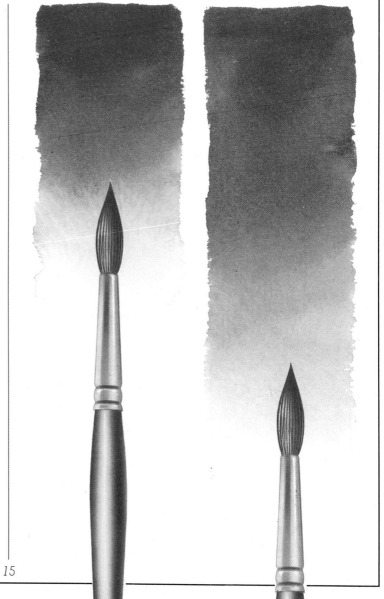

How to paint a gradation

First, pick up a little color with a brush that is slightly wet and paint a strip. Clean the brush in water and wet the paper below the strip.

While the strip is still moist you can extend the color with brushstrokes down into the wet area.

When the color has been used up, stop. Clean the brush, dry it with a paper towel, and place it in the middle of the gradation.

Pick up any water that has accumulated and continue to extend the color while retouching the previous area.

How I paint...

How to superimpose layers of color

In watercolor painting you must first *paint the light colors and then the dark ones.*

This procedure allows the buildup of darker colors by means of *additional layers of colors.*

If you paint with a very diluted color, you will obtain a very clear tone. If you wait until it dries and apply a new layer, you will obtain a darker tone.

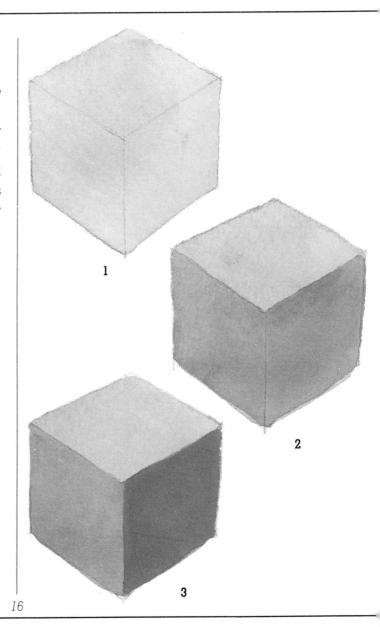

As you know, watercolor painting is characterized by transparency. This allows the creation of darker tones by superimposing layers of color. This means painting one layer on top of another. (1) First paint all sides of the cube with the same value of a color. (2) Wait until it dries and apply another layer on the darker areas. (3) When they are dry, apply a new layer on the darkest plane.

Reserving whites

Reserving whites means that white or light areas must be left white or *reserved*.

Reserving whites implies that before beginning to paint, a drawing must be done to indicate—or to *reserve*—where the white areas will be.

Modifying colors

In the previous exercises we have used one color; but watercolor painting usually involves many colors.

Does this mean you should use a different brush for each color? Not at all. You just need two or three *brushes that you must clean after applying one color and before picking up a new one*. Otherwise, the brush would make the new color dirty.

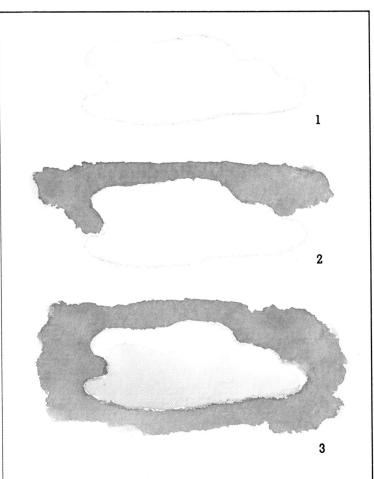

If you paint a watercolor with white or light areas you must *indicate where they will be*. In the following example, paint the sky, *reserving white* areas for the clouds. (1) Draw the clouds and (2) paint the sky outside the pencil lines. (3) Then, if you wish, you can shade in the clouds.

Color

The three primary colors

Among the colors in your watercolor box are the *three primary colors—blue, red,* and *yellow.*

Mixing each of the three primary colors with another yields three new colors: *purple, green* and *orange,* which are called *secondary colors.*

The color wheel

By continuing to mix each of the adjacent colors we can create a *chromatic wheel* of 12 colors. This wheel will help explain the relationship of the most important colors.

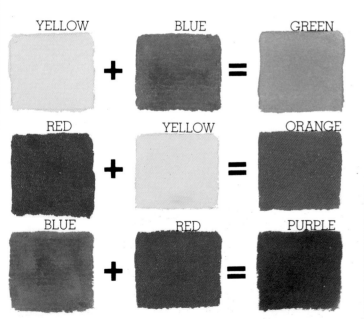

YELLOW		BLUE		GREEN
	+		**=**	

RED		YELLOW		ORANGE
	+		**=**	

BLUE		RED		PURPLE
	+		**=**	

Here you can see that mixing the three primary colors yields three secondary colors. These, in turn, mixed with the primaries give us six tertiary colors.

Colors that are opposite each other on the color wheel are called the *complementary colors*.

With complementary colors the most intense contrasts can be achieved.

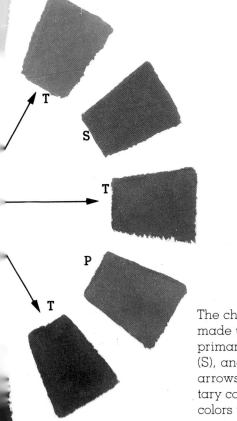

The chromatic wheel is made up of 12 colors: 3 primary (P), 3 secondary (S), and 6 tertiary (T). The arrows link complementary colors—that is, those colors that contrast the most.

Color and value

The color of objects is lighter or darker depending on the effect of light and shadow.

Value is the degree of lightness or darkness of a color depending on the lighting or shading of an object or a part of an object.

In the sphere below, which is lighted on the upper area, different values of blue can be seen from the lightest blue, almost white in the lighted area, to the darkest blue, in the shadows.

DIFFERENT VALUES
OF A COLOR:

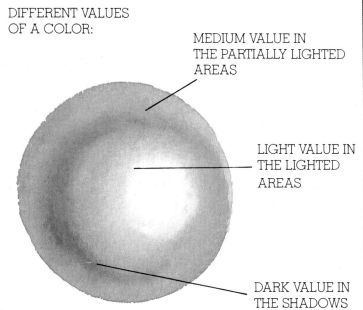

MEDIUM VALUE IN THE PARTIALLY LIGHTED AREAS

LIGHT VALUE IN THE LIGHTED AREAS

DARK VALUE IN THE SHADOWS

My first exercises...

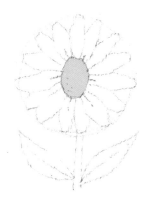

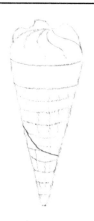

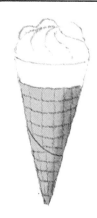

Draw a circle enclosing the petals, two lines for the stem, and two for the leaves.

With a fine brush paint the center of the daisy dark yellow without going outside the pencil lines.

Draw a cone in as much detail as possible. Don't press the pencil too hard against the paper.

Paint the cone orange with a very wet brush. Before the watercolor dries, paint the darker gradation with a drier brush.

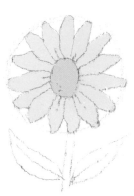

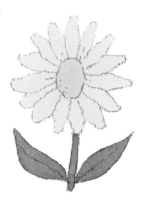

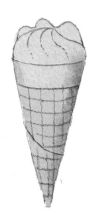

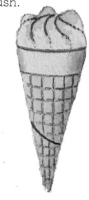

Clean the brush and paint the petals light yellow; follow the pencil line and then fill in with color.

With a clean brush outline the stem and the leaves with light green and then fill in with color.

Blend blue and red and paint the ice cream. When it dries do a little gradating with the brush loaded with more color.

Paint the ice cream light yellow and the cone lines brown.

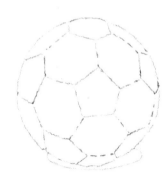

Draw a circle to *enclose* the ball shape. Then draw the design of the stitching.

Paint the ball dark yellow. Wait until it dries a little and then gradate the color using a wet brush.

Carefully draw the upper area and the base of the jar. Draw the base with a complete oval. The curve in back of the jar should be erased later.

Paint the jar light yellow. When it is slightly dry, add a bit of orange and gradate.

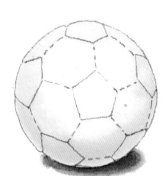

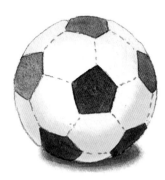

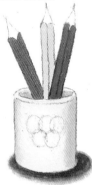

Blend blue and a bit of red and paint the shadow. As before, wet the brush and gradate the shadow.

With the brush slightly wet, use brown to fill in the center and upper designs. With a drier brush paint the designs below.

Paint each pencil with a very wet brush. Then, blend blue with a bit of red and paint the shadow cast by the jar.

Add another layer of the original colors on the dark areas of the pencils. This time, use more color with a drier brush.

21

My first exercises...

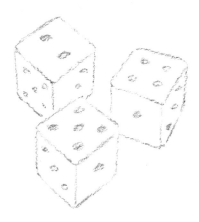

Now you will practice painting different values of the same color. You will have to decide whether you should use a lot or a little water to obtain a lighter or a darker tone. Begin by drawing the dice.

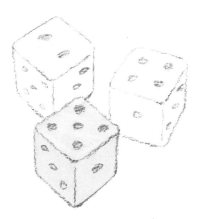

Pick up some light yellow with a lot of water and paint an even background for one die. It doesn't matter if you paint on the pencil lines, but try not to go outside them.

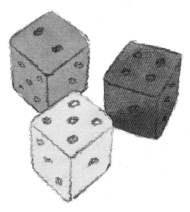

Wait until the color is dry to paint the other dice. Wet the brush, moisten the cake of light green, and paint an even background. Do the same for the third die in light red.

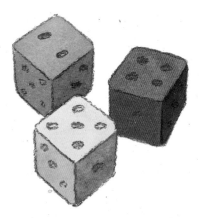

When the colors are dry you can begin painting the sides of the cubes. Wet the color to paint lighter areas and use an almost dry brush to paint the darker areas.

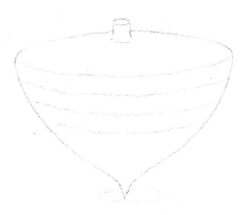

In this exercise you will learn to paint several stripes in different colors. In watercolor it is very important to learn how to paint two or more contiguous colors without dirtying them.

Paint an even background in light yellow, reserving the highlights. Before the color dries completely, blend yellow and a bit of orange and gradate the color on the right side of the top.

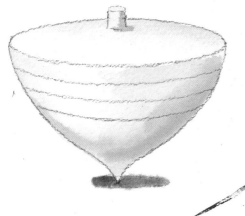

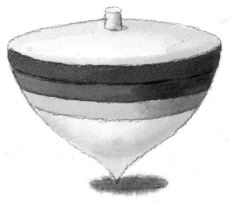

Continue gradating with yellow and orange to emphasize the form of the top. Blend blue and a bit of red on the cover of the watercolor box. Paint the shadow of the top and gradate the color with a dry brush.

Paint the stripes orange, blue, and yellow. Let each stripe dry before painting the next one. Paint the shadows on the right with drier orange and blue and add a bit of yellow ocher to the yellow.

23

My first exercises...

Paint this apple and you'll learn how to gradate a color to paint shadows. First, draw the subject carefully pointing out the highlights.

Wet the brush and put light yellow on the cover of the watercolor box. Add more water if necessary to achieve a lighter tone. Pick up the color and paint the upper part of the apple.

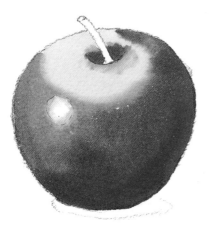

Clean the brush and pick up a little red. Paint from below and extend the color until it reaches the still wet yellow color. Then, paint a red stripe on the right side.

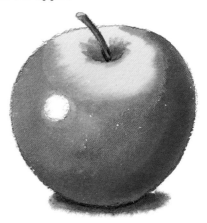

Wet a fine brush and pick up light green to paint the apple stem. When it is dry, paint the shadow dark green. Clean the brush and paint the shadow of the apple blue with a bit of red.

To draw the house, you must be sure that all of the vertical lines—walls, door, windows—are parallel. The horizontal lines rise as they approach the front of the picture (foreground) and fall as they move back (background). Only the horizon is drawn as a horizontal.

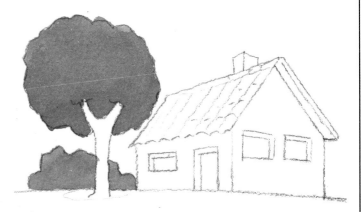

Wet the brush and paint the treetop light green, outlining the upper part and extending the color down. Outline the lower part and fill in the rest with color. Wet the brush and paint the bush.

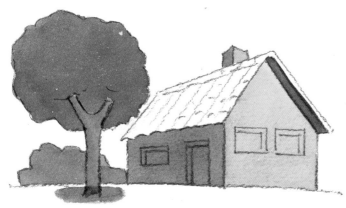

Paint the house with very wet yellow ocher. When the color is dry blend yellow ocher with a bit of brown and paint the front of the house darker. Do the same with the chimney. Then paint the tree trunk.

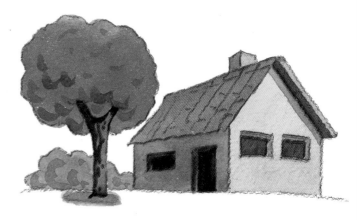

Paint the roof; use more water with the red to paint the lighter areas. Use dry yellow ocher on the roof shadows and on the windows. Using very little water, paint the tree and bush shadows dark green.

25

My first exercises...

The four exercises that follow will let you practice everything you've learned about watercolor.

Read the text and look at the illustrations to find out what to do to paint every exercise.

Don't concentrate on only the last illustration. Work every page step-by-step in the order suggested.

Besides the illustrations showing you every step, you will find some illustrations that explain how to paint certain details.

Now, begin painting your first watercolor.

Paint your first water-colors following the step-by-step directions. First, paint these building blocks to practice painting different values.

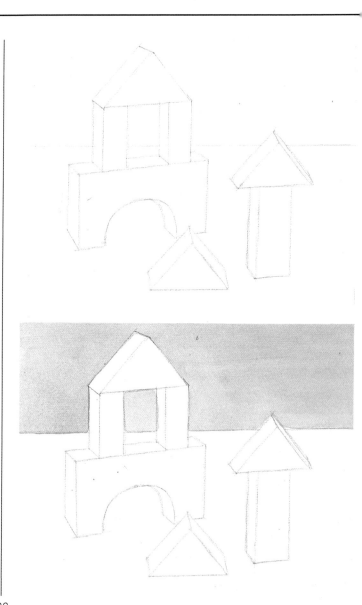

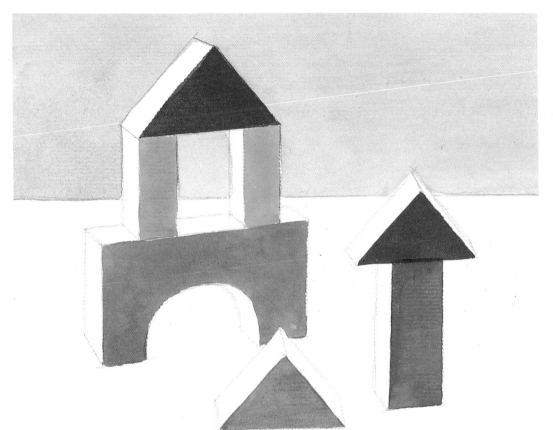

When applying paint, outline the lines of the drawing, then extend the color.

Draw the subject without pressing the pencil too hard against the paper.

Paint the background with light blue and a small amount of yellow ocher. Begin on the horizontal line and extend the color upward.

Wait until the background is dry before painting the building blocks.

Paint the different pieces red, light yellow, orange, light green, and light blue.

27

My first exercises...

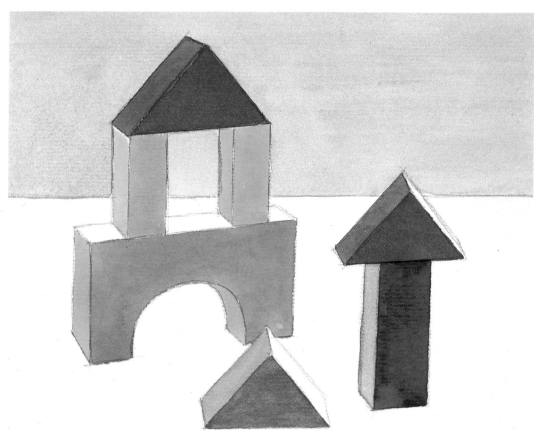

Paint the sides with a fine brush, adding a lot of water to the cake of color.

Now you are going to paint the sides of the objects in lighter values of the previous colors. Use a fine brush and quite a lot of water.

Before painting, test the colors on the cover of the watercolor box to check that the tone is light enough.

If you feel it is still too dark, add some water.

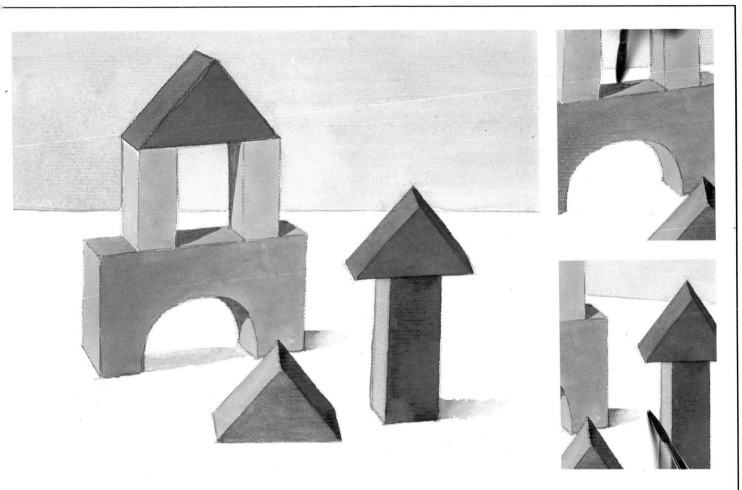

Now paint the upper part of the arch-shaped piece with yellow and a small amount of red.

Paint the red triangles with red and a little bit of blue, and the green triangle with dark green.

The dark tone is obtained by using a fairly dry brush.

Finally, use a nearly dry brush and paint the inner shadows of the arch in brown. Use blue and a lot of yellow ocher for the other shadows.

29

My first exercises...

In this exercise you will practice a very important technique: painting even backgrounds and gradated backgrounds. Draw everything that you see on this page in as much detail as possible.

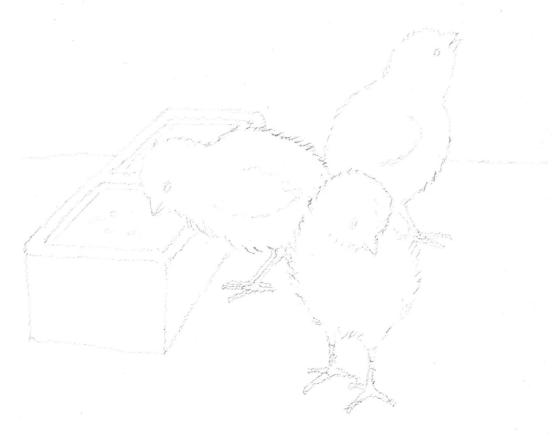

In this exercise you'll continue working on backgrounds. You will also practice drawing outlines and filling them in with color.

Draw the shape of the little chicks and the feeder.

Draw all the lines necessary to separate each object in the picture.

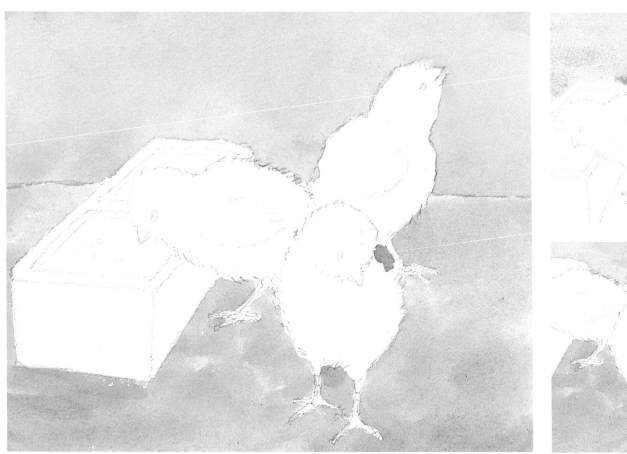

First, paint the upper background. Pick up light green with a thick, wet brush.

Paint horizontal brushstrokes from left to right and flow the paint down, extending the wet color to the pencil line.

When the color is dry, clean the brush and paint the lower background in yellow ocher with a lot of water.

My first exercises...

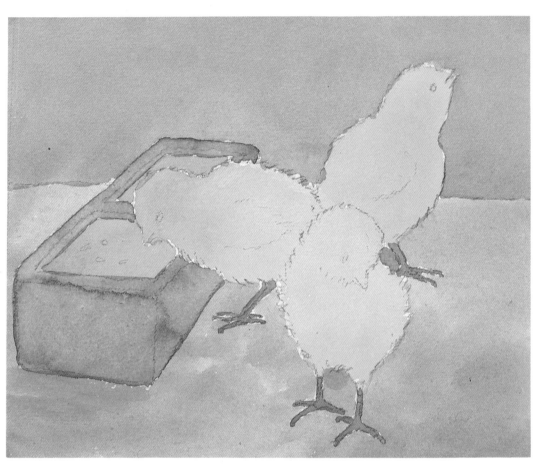

When the backgrounds are dry, wet a medium-size brush and paint the three chicks light yellow with a lot of water.

Paint along the pencil lines but without going outside the chicks' outlines.

Clean the brush and paint the corn orange and the feeder brown.

Using a fine brush, paint the chicks' legs orange and then outline the feeder dark brown.

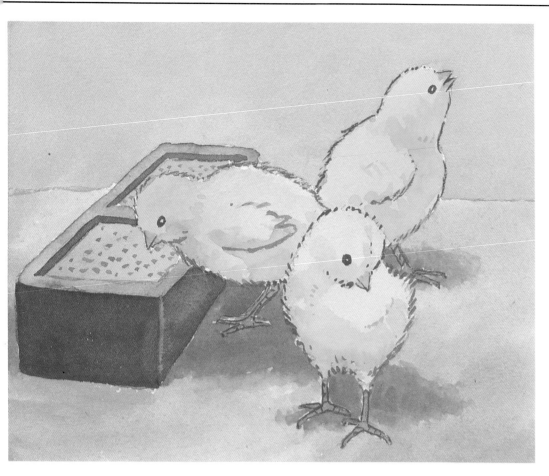

Paint the chicks' contours with a fine brush; use short brushstrokes for the feathers.

Use a fine brush and paint the dark side of the feeder brown. Add some water to paint the light side.

Blend light yellow with some orange and paint the chicks' wings.

Still using the fine brush, paint the finishing details. Use brown for the eyes and red mixed with brown for the chicks' contours and the shadows of the wings.

My first exercises...

This sailboat is a good exercise for practicing background painting—sky and sea—and to learn to paint without dirtying colors.

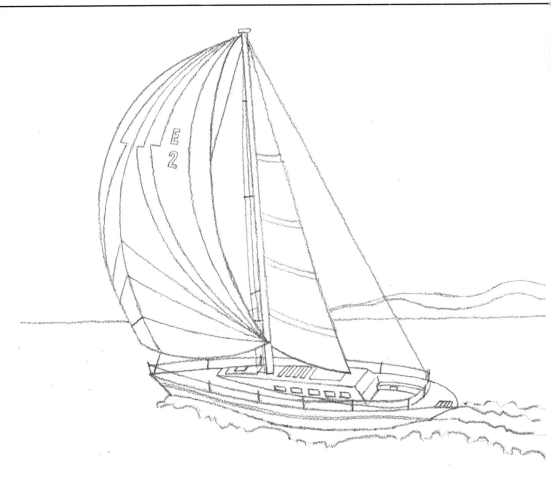

To draw the mainsail and the hull of this sailboat, follow the drawing on this page. For the jib and the mast, use a ruler.

Don't press the pencil too hard against the paper. Also draw the horizon line and the shape of the mountain. Draw the waves made by the sailboat, so you can reserve them later when you begin painting.

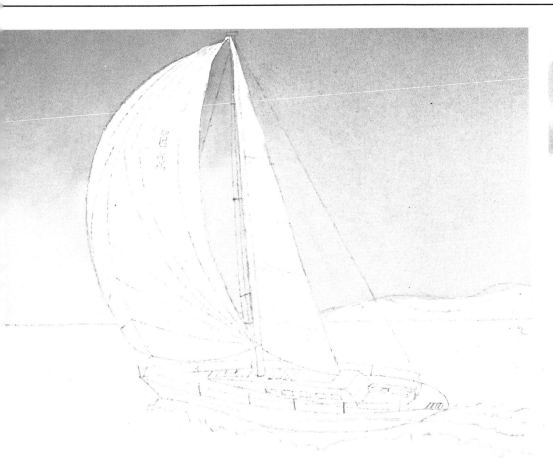

It is important to paint an even background without streaks of color. Also, avoid going inside the area of the sails.

Begin painting the sky light blue with a thick wet brush. Use horizontal brushstrokes and take care to leave the sails white.

Paint in long, continuous brushstrokes to avoid streaking caused by drying paint.

Dry the brush and rapidly gradate and harmonize color in the same area you've just worked on.

My first exercises...

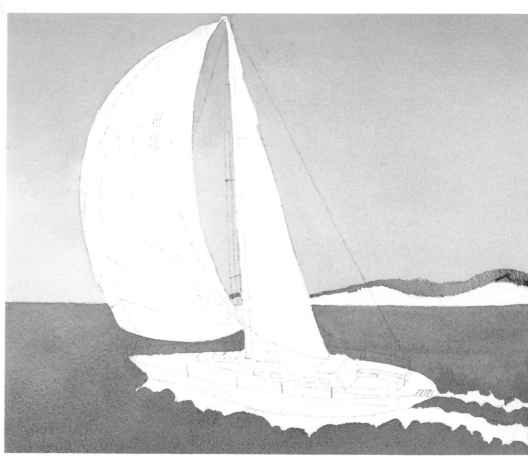

Below the sailboat, extend the color to the pencil lines to define the waves.

Clean the thick brush and begin painting the sea dark blue. Extend the color from the horizon line downward. Before it dries, apply paint with less water to the bottom foreground, thus darkening it.

Be careful not to go past the pencil line when you're painting the lower part of the hull.

Use a medium brush to paint the mountain light green. Use less water to paint the shadows.

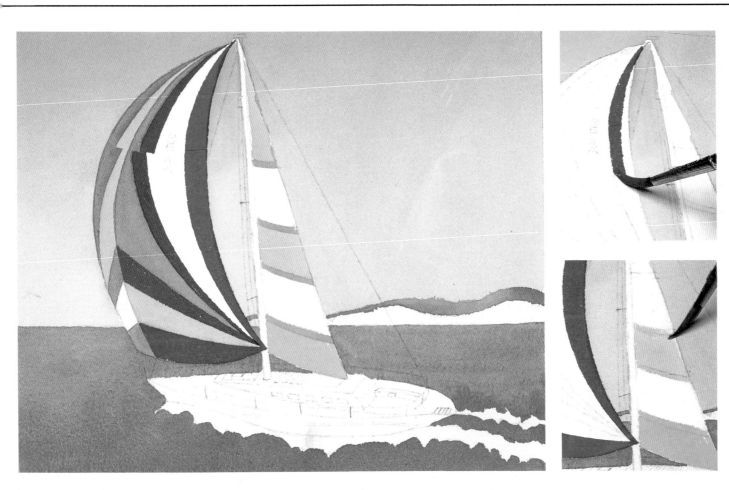

Paint the stripes of the sails: first the pencil lines, then the color of the stripe.

Use red, blue, and light green for the main-sail and light yellow for the jib.

When the colors are dry, paint the dark tones in the same colors but with a drier brush.

My first exercises...

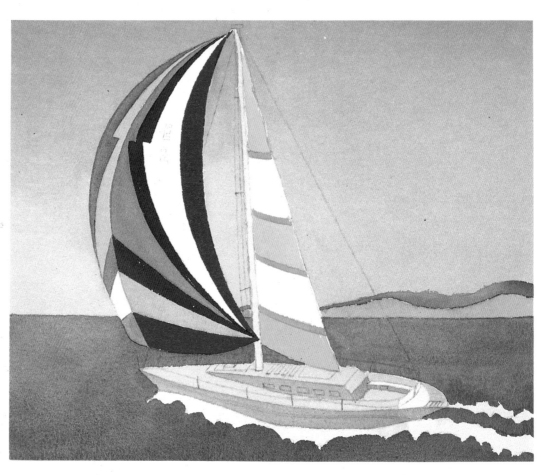

Pick up light blue with a fine brush and, with even brushstrokes, paint the hull and deck.

When the color is dry, paint the stripe on the hull and the windows light blue with a drier brush.

Then, paint the hull dark blue, first outlining the contour.

Finally, with a drier brush, gradate the right side of the hull.

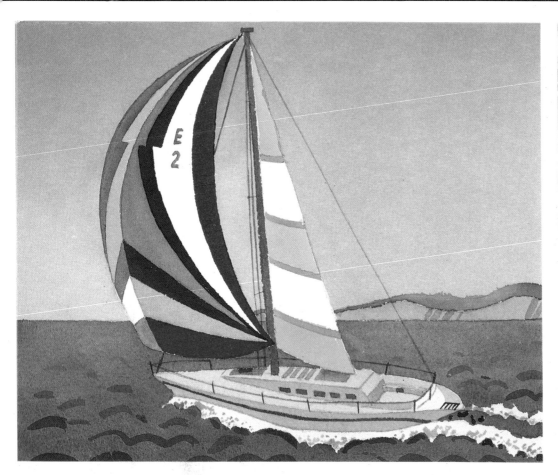

Use a fine brush with very little water to paint the windows dark blue over the light blue background you've already painted, which should be dry.

Now paint the finishing details.

Blend dark blue and a little red and add water until you obtain the violet color of the railing and other details on the deck.

Paint the foam of the waves light blue, making slight splashes with the same brush.

Finally, paint the waves that will be darker in the foreground and lighter in the background.

It should make a wonderful watercolor!

My first exercises...

In this landscape you can practice everything you've learned about watercolor. First, draw all the details, paying special attention to the houses and the tower.

Study this landscape carefully. It will enable you to practice everything you know about watercolor painting—background and gradations, outlining shapes and filling them in with color, and, above all, gradating colors to paint shadows.

First, complete the sketch. Just outline the houses and landscape—without any shading.

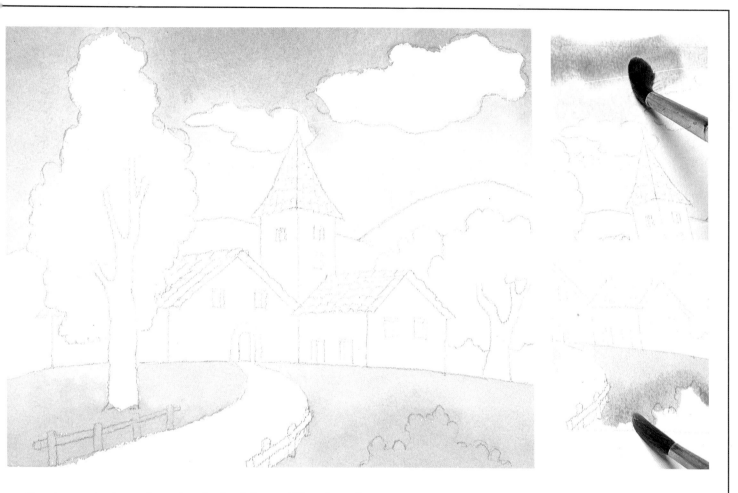

Begin painting the sky light blue. Wet the brush and flow on the color. Then, pick up some more color with a drier brush and apply brush-strokes to the upper part.

Paint the meadows. Blend green with some yellow and flow the color downward.

With a drier brush, paint the foreground and gradate upward for a lighter green.

My first exercises...

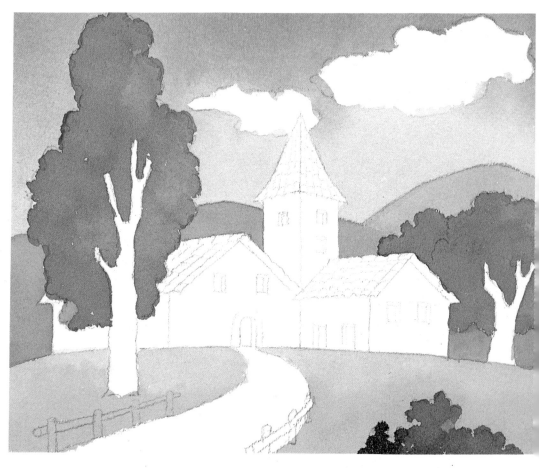

Paint the trees, extending the color with enough water. Paint the outline of the branches when you paint the lowest part of the treetops.

Now, paint the mountains. Use green with some blue to paint the mountain on the right. Add a bit of green for the mountain on the left.

Pick up some more green with a wet brush and paint the trees. First, paint the shape of the treetops and then, fill in with color.

Before it dries, work in the color with a fine, dry brush to obtain shades.

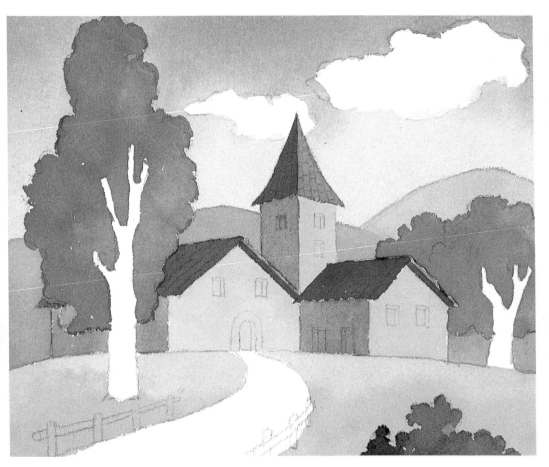

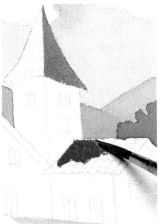

Paint the roofs red with an almost dry brush, beginning as always with the pencil line. Use a wet brush to paint the highlighted area on the roof of the tower.

Use red with a wet brush for the roofs. Use a drier brush for the darker areas.

Clean the brush and paint the front of the houses and the tower. Use a wet brush with yellow ocher for the light tones and brown with green for the dark ones.

Use brown with a little green under the eaves.

My first exercises...

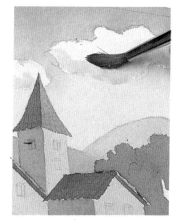

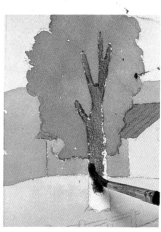

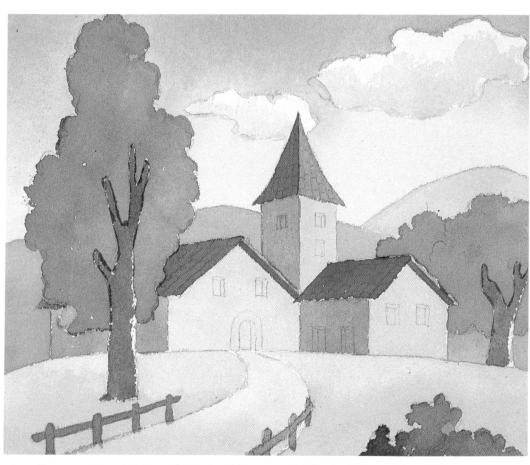

Now, paint the path dark yellow and red. Use a lot of water to extend the color. Paint the foreground of the path with less water than the background and then link both tones.

Paint the shadows of the clouds, gradating light blue and dark blue. Blend brown and green to paint the branches and trunks of the trees.

Clean the brush and paint the fences brown with some yellow ocher.

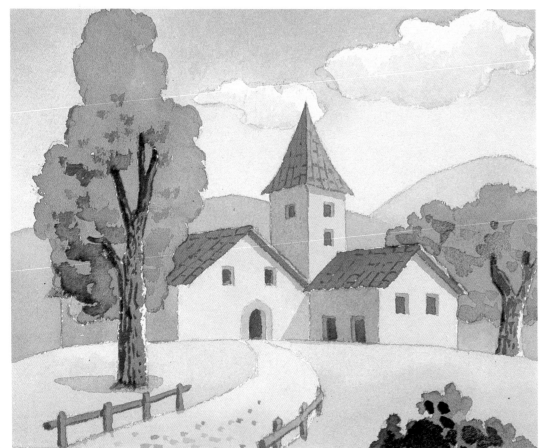

Blend dark green and a little brown. Then, paint the tree shadows with a fairly dry brush.

Use a fine brush to paint the finishing details. With very little water, use yellow ocher and some green for the shadows cast by the buildings.

Paint the doors and windows with yellow ocher and brown, using a lot of water. The shadows formed by the treetops and trunks are brown with some dark green. Paint the stones on the path orange with quite a lot of water.

Glossary

chromatic circle. A circle made up of twelve colors: three primaries, three secondaries, and six tertiaries. Another name for chromatic circle is color wheel.

complementary colors. The secondary color obtained by mixing two primary colors, which is said to be complementary to the third primary color (for example, green, obtained by mixing blue and yellow, is complementary to red).

composition. The arrangement of all elements of a subject in a pleasing way.

contour. The outline of a shape.

cool colors. Those that in the color wheel are located between green and violet, with both these colors included.

form sketch. Preliminary lines in a drawing that set down the basic forms of a subject by means of simple geometric shapes (squares, rectangles, circles, etc.).

gradation. The gradual shift from a darker tone to a lighter one or vice versa.

grid sketch. A box containing evenly spaced horizontal and vertical lines that is used when making a copy of a drawing.

harmonize. Setting down colors so that none clashes with the others.

optical mix. The effect achieved by super-imposing layers of two (or more) colors that are blended by the eyes of the viewer to produce a third color.

outline. A quick sketch that with a few lines roughly sets down the basic elements of a subject.

palette. A thin board on which a painter mixes the color; also, the complete range of colors used by a particular artist.

perspective. Drawing rules for creating on paper, which has only two dimensions (length and width), the impression of the third dimension (that is, depth).

pigment. A colored powder obtained from earth, finely ground stones, vegetables, chemicals, etc., and mixed with a medium such as oil to make paints, with wax to make crayons, or with wax and clay to make colored pencils.

plane (or ground). Different levels of depth or distance in a scene. In a landscape, for instance, there may be: a foreground—the nearest; a middle ground—intermediate; and a background—more distant.

primary colors. Red, blue, and yellow; the colors that are blended to produce other colors, but that cannot themselves be obtained by any mixtures.

scale. A group of all the tone variations in a color.

secondary colors. Orange, purple, and green; the colors obtained by blending pairs of primary colors.

shading. Capturing light and shadows through gradation of different tones.

sketch. A rough drawing or painting in which the shape, composition, and tonal values of light and shadows are determined.

still life. A drawing or painting based on a collection of objects posed in a particular way by the artist.

tertiary colors. The colors obtained by blending a primary and secondary color (example, blue-green or red-orange.)

tone. Intensities of a color, from the lightest to the darkest.

transparent color. A layer of color through which the color underneath can be seen.

value. The degree of lightness or darkness of a color. A weak value is very light (or pale); a strong value is dark and intense.

warm colors. Those that in the color wheel are located between crimson and light yellow, with both these colors included.

Index